FIRECRACKERS!

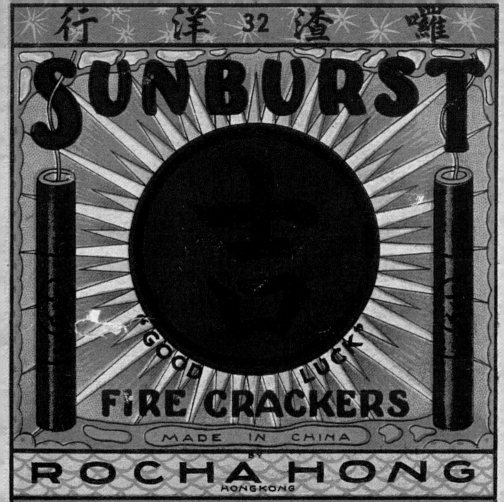

FIRECRACKERS!

AN EYE-POPPING COLLECTION of CHINESE FIREWORK ART

WARREN DOTZ

CONTENTS

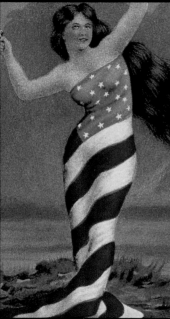

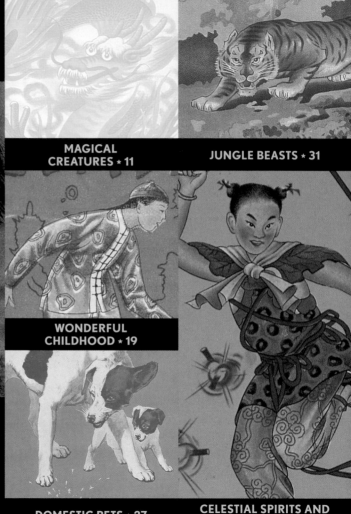

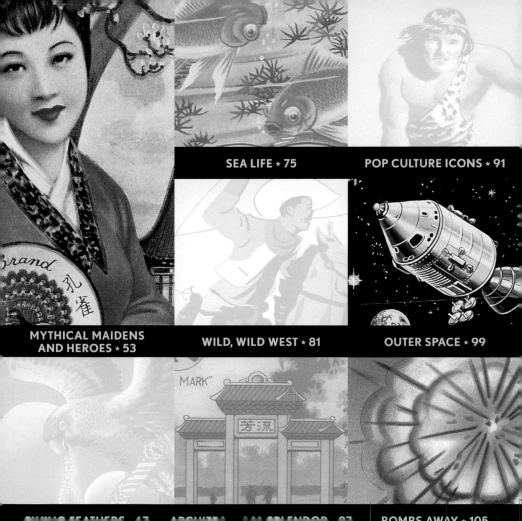

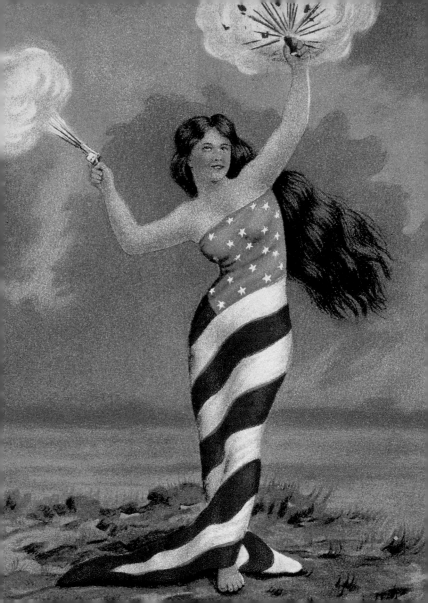

BANG FOR THE BUCK

An integral part of most Chinese celebrations, firecrackers punctuate the start of the New Year and the launch of new business ventures. Firecrackers highlight all holiday festivals, and weddings and funerals would be incomplete without them. In fact, there are few occasions in Chinese culture to which these ear-splitting, spark-spitting bundles of sound and fury aren't welcome.

Associated almost exclusively in the United States with Independence Day, firecrackers have become an enduring icon of American culture. Often forgotten is that firecrackers, once made simply from bamboo, originated in China over a thousand years ago. When the more sophisticated paper and powder-packed firecrackers arrived on our shores, their popularity grew quickly, and by the end of the nineteenth century they were firmly imbedded as part of the nation's July Fourth celebrations.

Because firecrackers were so inexpensive to produce, competition for both the domestic and export markets was fierce among manufacturers. Product packaging became a crucial component to capturing and keeping customers. Even more so than other product advertising, Chinese firecracker labels abound with traditional imagery, including dragons and phoenixes, moon goddesses and thunder gods, tigers, bats, and peony blossoms.

In an effort to appeal to their principal overseas market—young boys and teenagers—many Chinese manufacturers appropriated all-American pop-culture motifs for their pack labels. Illustrated in the brilliant kaleidoscopic colors of comic books, cowboys, Indians, GIs, rocket ships, Tarzan, and King Kong (with pink wings) were portrayed with a uniquely whimsical charm. This fanciful union of art and advertisement fused China's rich visual heritage of symbols and mythology and America's equally vivid repertoire of folk and pop iconography.

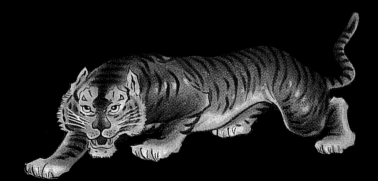

MightyMite

Super Charged Flash Cracker

BRAND

1CC CLASS C
COMMON FIREWORKS

1" 40/100

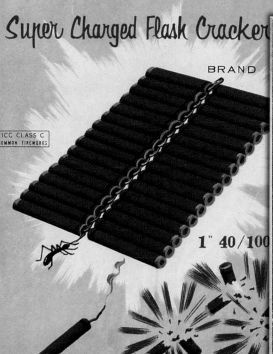

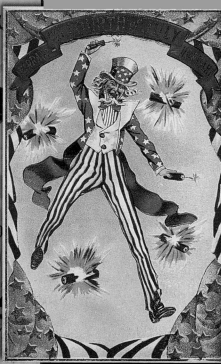

MADE IN MACAU

LAY ON GROUND-LIGHT FUSE-GET AWAY QUICKLY

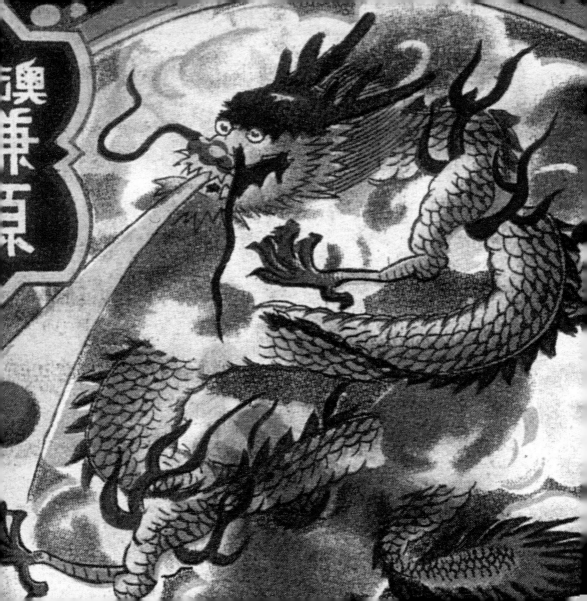

MAGICAL CREATURES

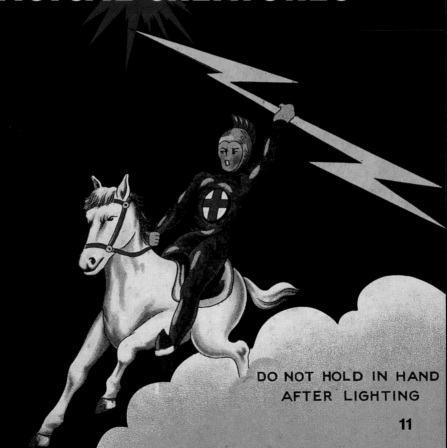

DO NOT HOLD IN HAND
AFTER LIGHTING

11

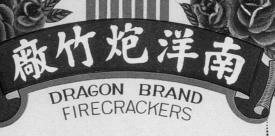

南洋炮竹廠

DRAGON BRAND
FIRECRACKERS

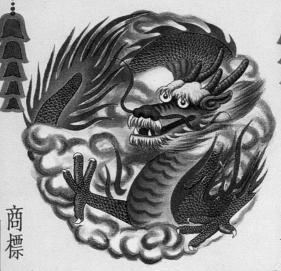

商標

團龍

NAM YANG

MADE IN PORTUGUESE MACAU

頂電靚光炮竹

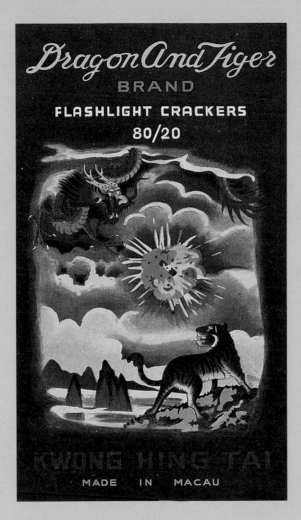

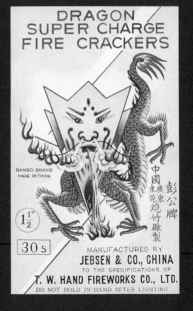

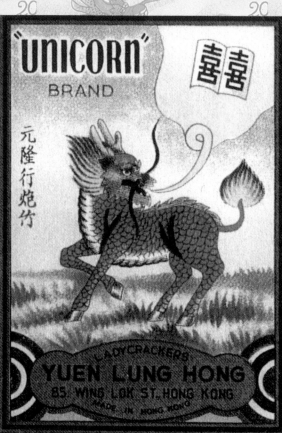

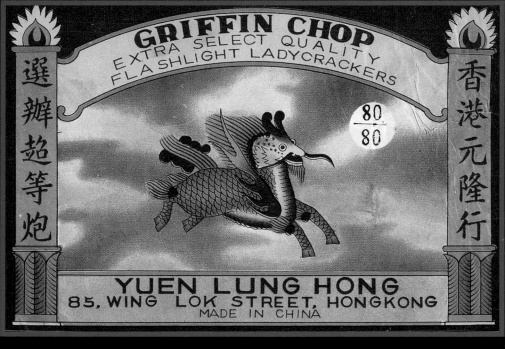

15

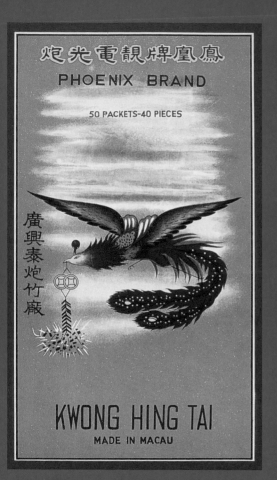

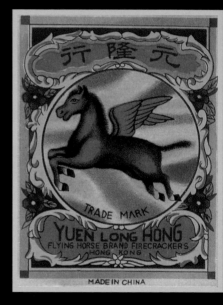

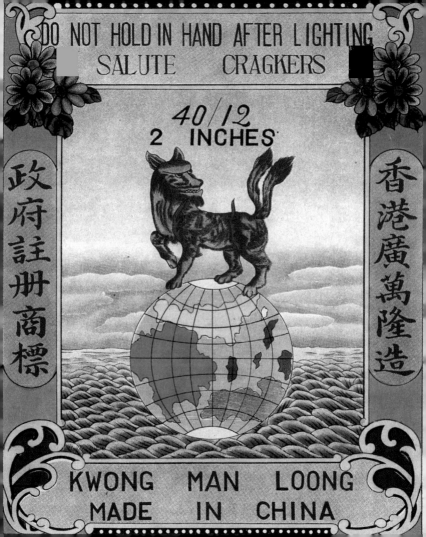

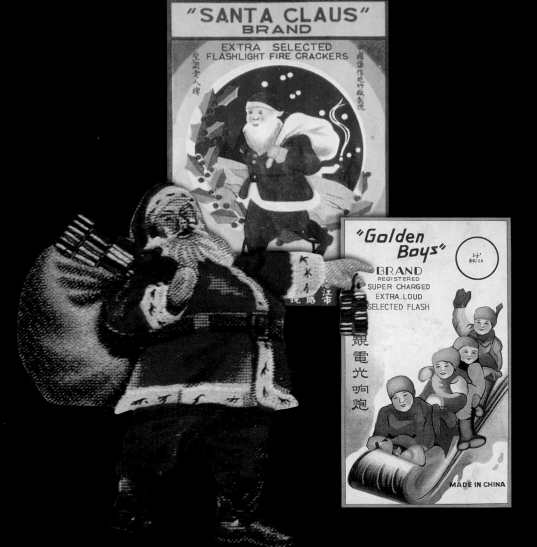

WONDERFUL CHILDHOOD

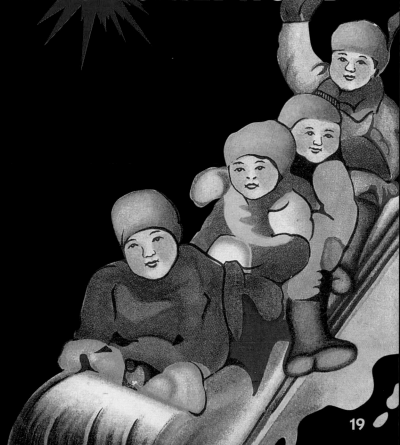

19

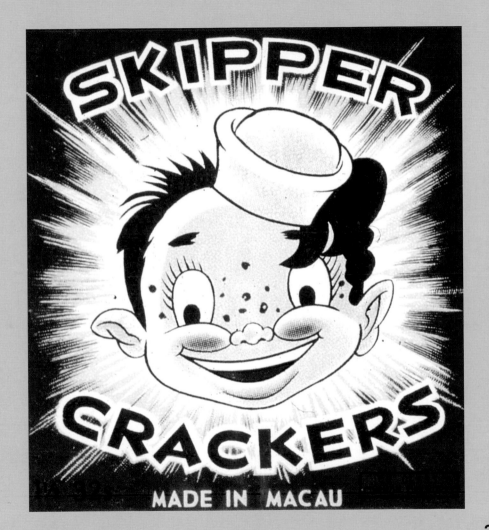

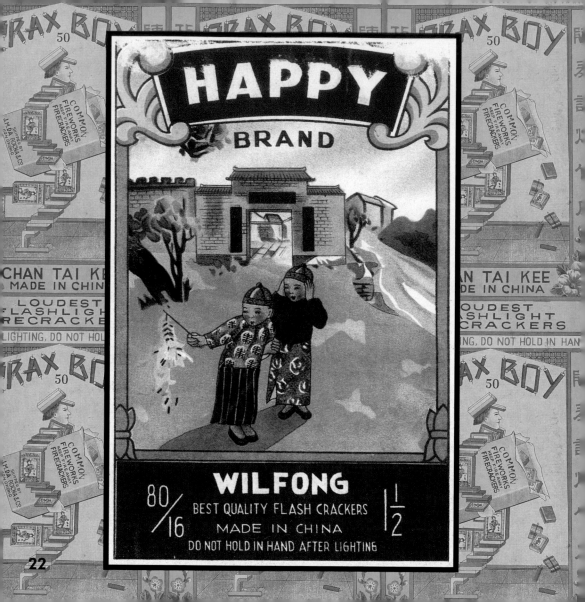

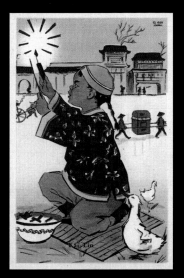

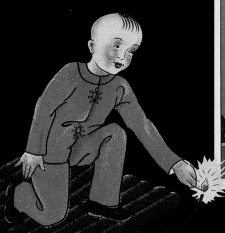

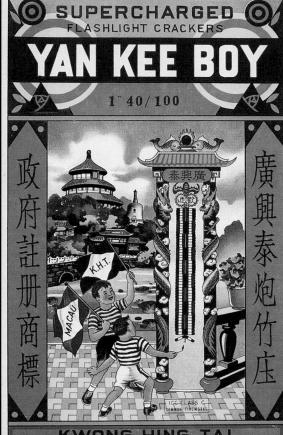

SUPERCHARGED
FLASHLIGHT CRACKERS

YAN KEE BOY

1" 40/100

政府註冊商標

廣興泰炮竹庄

泰興廣

K.H.T.

MACAU

ICC CLASS C
COMMON FIREWORKS

KWONG HING TAI
MADE IN MACAU

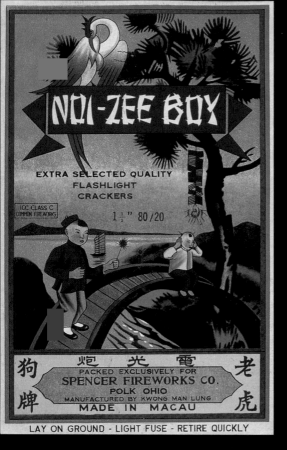

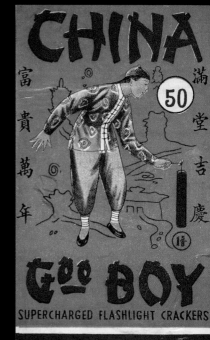

24

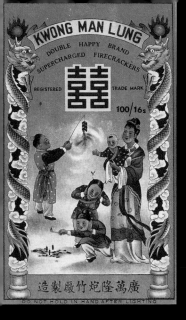

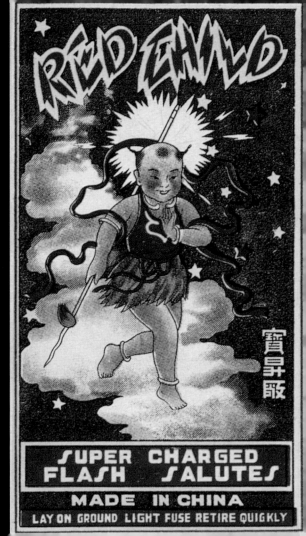

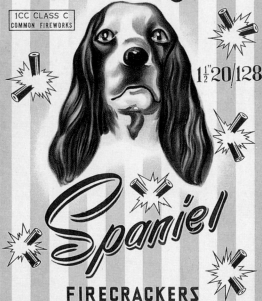

DOMESTIC PETS

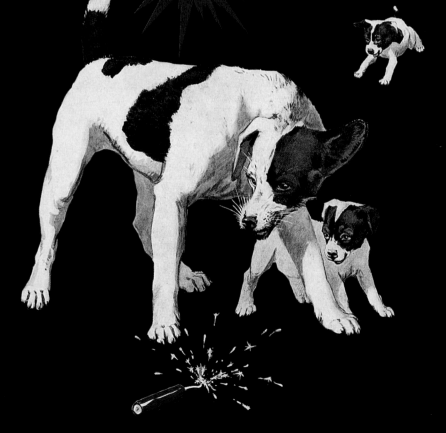

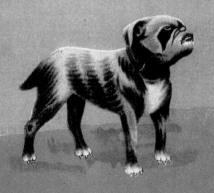

VERY BEST
FLASHLIGHT
FIRE CRACKERS
BULLDOG
BRAND
MANUFACTURED BY
TO YIU
CANTON, CHINA.

廣州市道糧廠造

老虎狗牌電光炮

50 REPORTS

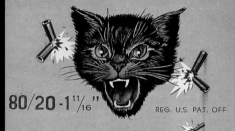

DO NOT HOLD IN HAND AFTER LIGHTING

Black

80/20 -1$\frac{11}{16}$"

REG. U.S. PAT. OFF

Cat

SUPERCHARGED
FLASHLIGHT CRACKERS
MADE IN MACAU

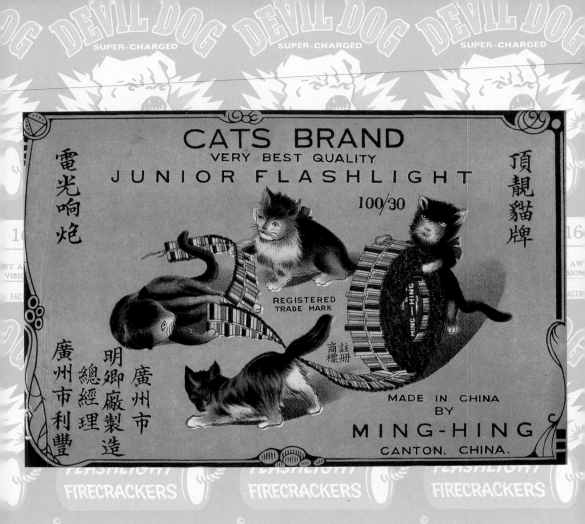

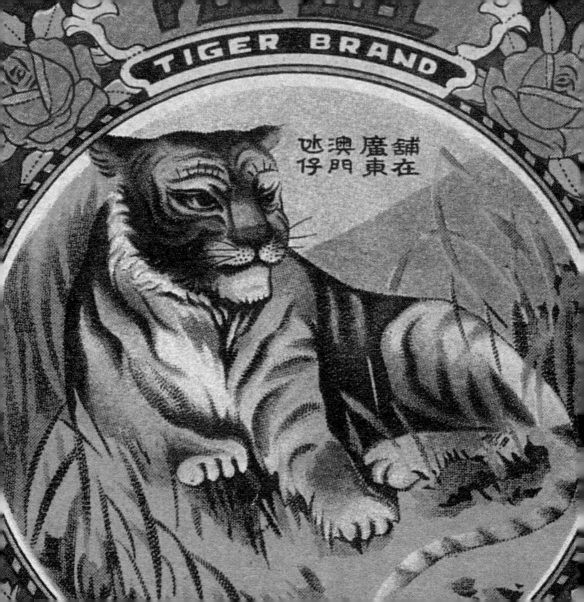

JUNGLE BEASTS

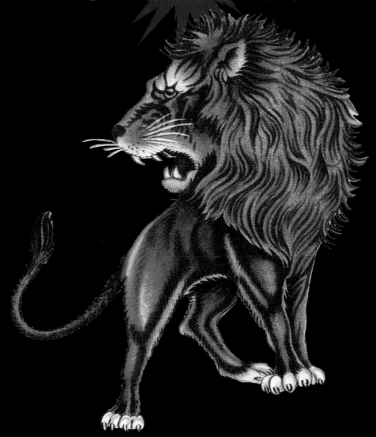

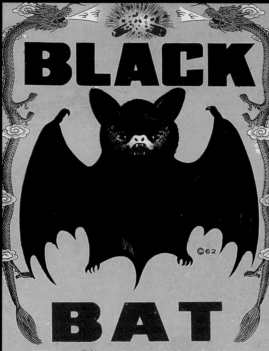

BLACK

BAT

SUPERCHARGED FLASHLIGHT CRACKERS

1½"

I.C.C.-Class C
COMMON FIREWORKS

80/16s

CAUTION - EXPLOSIVE
LAY ON GROUND - LIGHT FUSE - GET AWAY
USE ONLY UNDER ADULT SUPERVISION

 MADE IN MACAU
BY *Kwong Hing Tai* FIRECRACKER CO.

©62

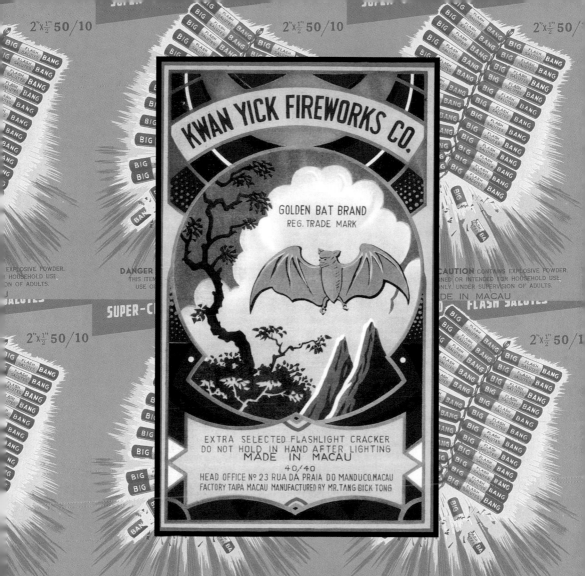

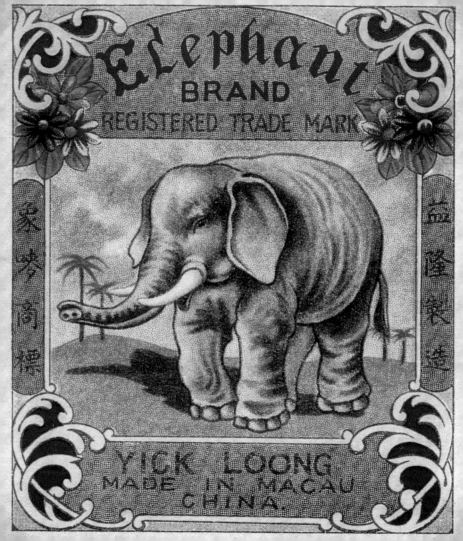

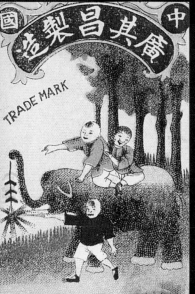

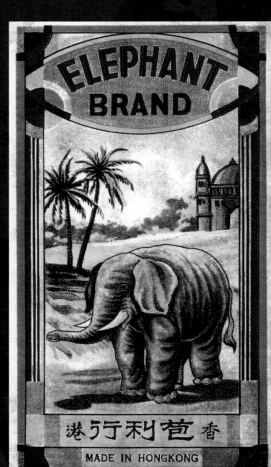

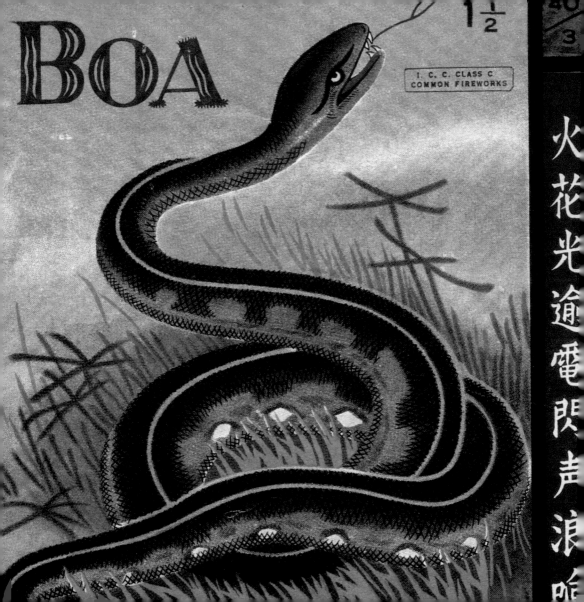

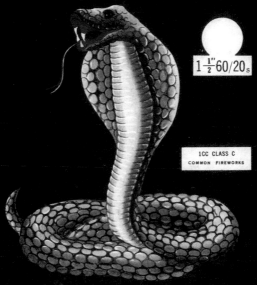

Cobra

SUPER CHARGED FLASHLIGHT CRACKERS

$1\frac{1''}{2}$ 60/20s

1CC CLASS C
COMMON FIREWORKS

THE CRACKER WITH A

MADE IN MACAU
CAUTION-EXPLOSIVE
Lay on Ground, Light Fuse—Get Away,
Use only Under Adult Supervision.

PO SING FIRECRACKER FTY.

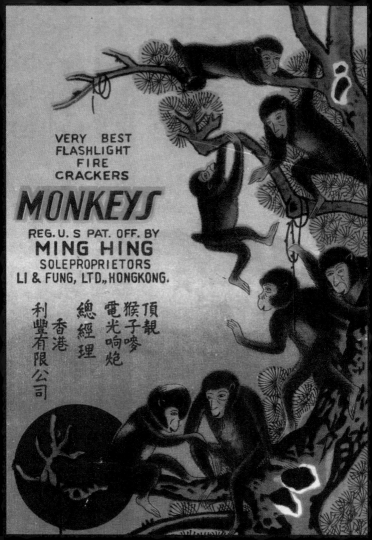

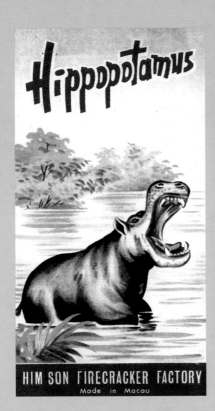

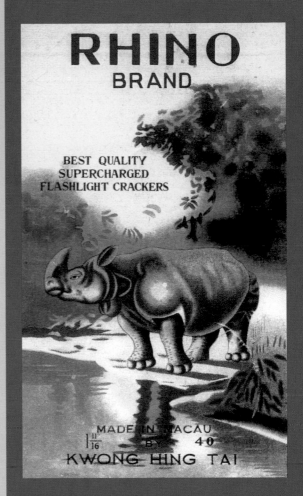

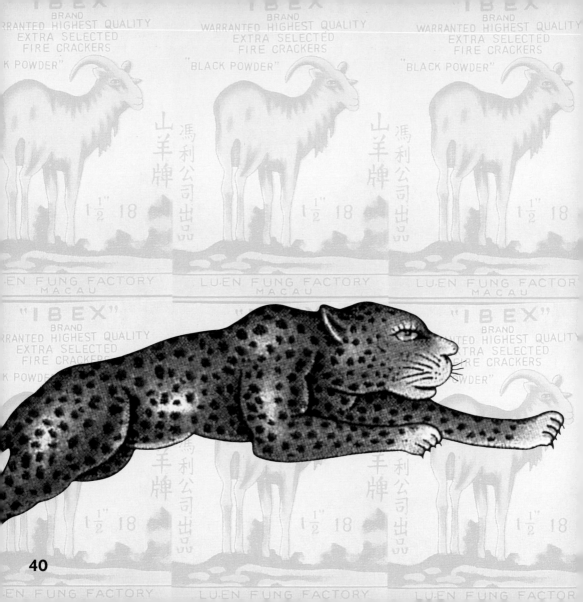

40

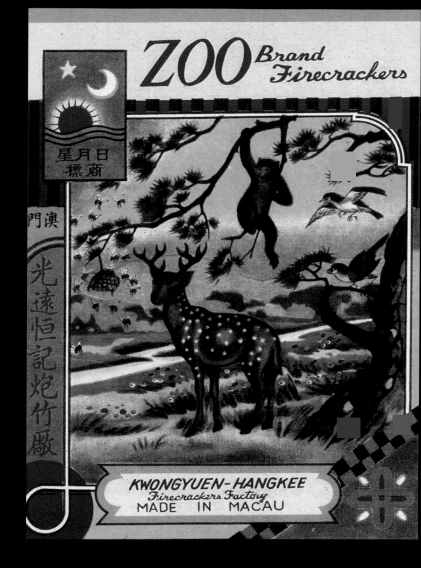

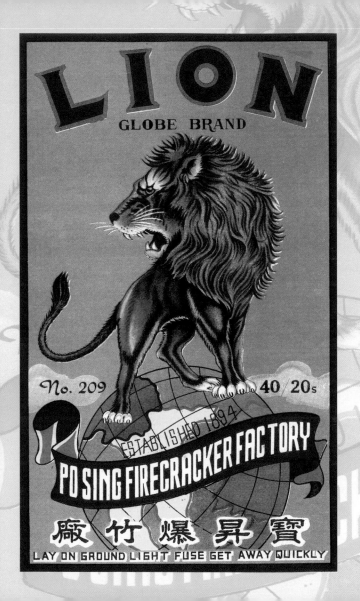

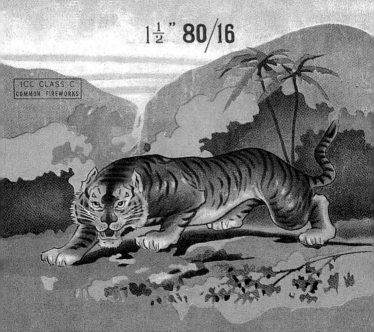

GIRAFFE
BRAND REG.

馳名長頸鹿電光炮

香港利豐有限公司

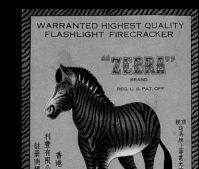

"ZEBRA"
BRAND
REG. U. S. PAT. OFF

香港
利豐有限公
註冊商標

頂真馬牌上等電光
輕巧馬牌上等電光

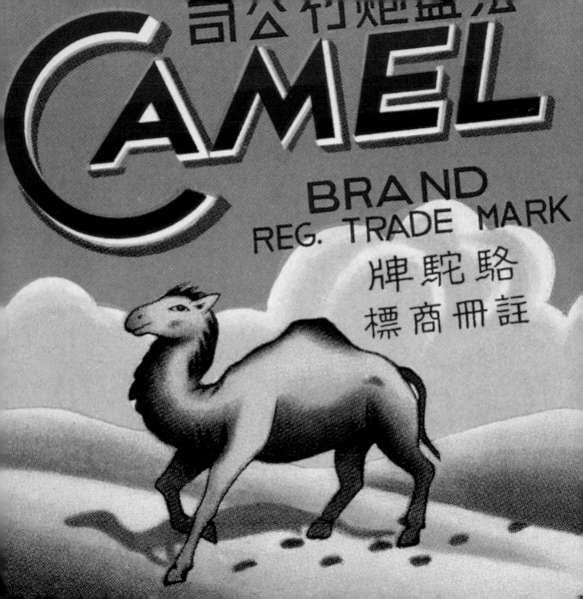

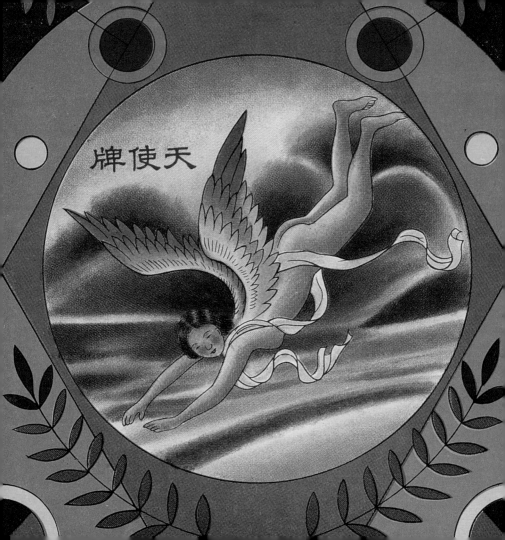

CELESTIAL SPIRITS AND DEVILISH DIETIES

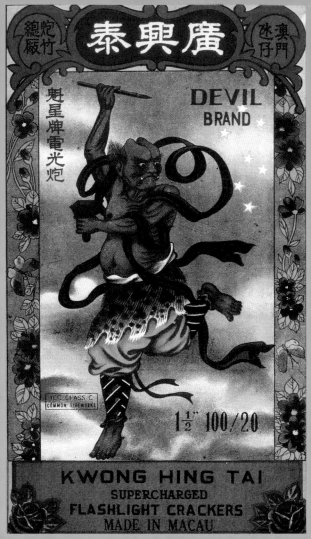

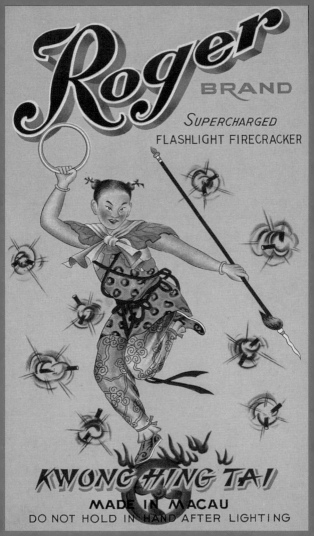

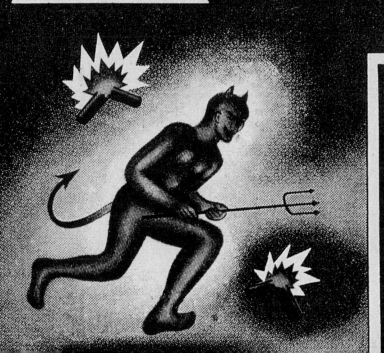

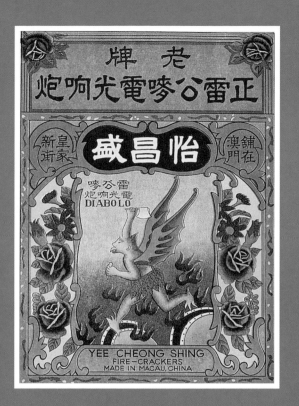

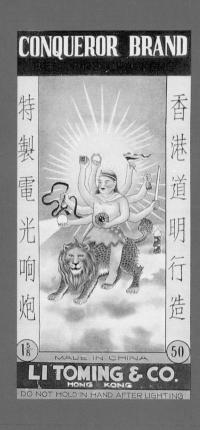

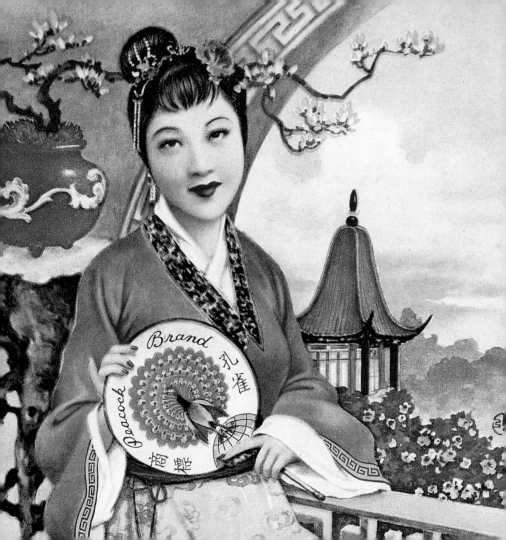

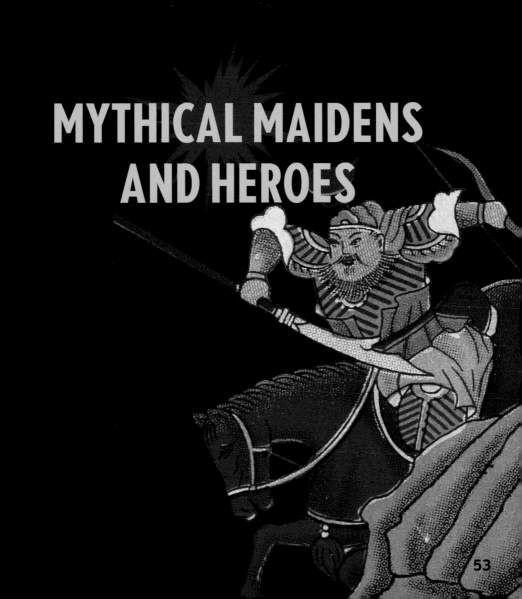

MYTHICAL MAIDENS AND HEROES

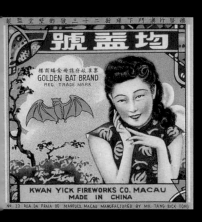

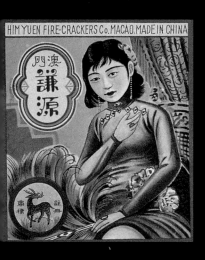

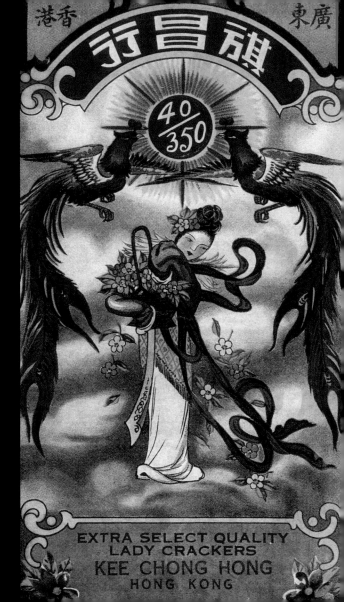

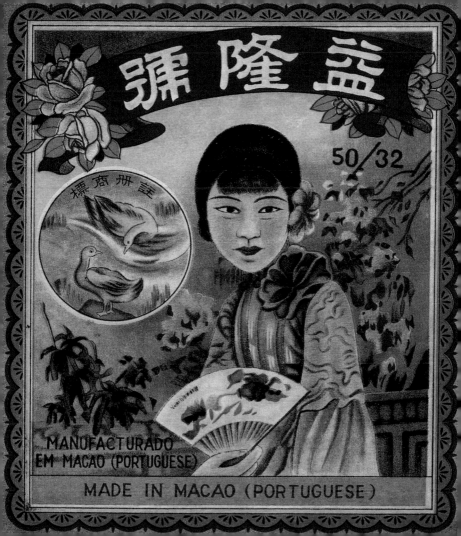

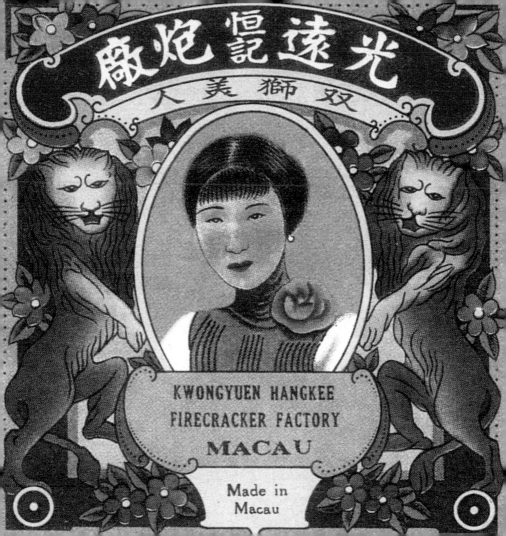

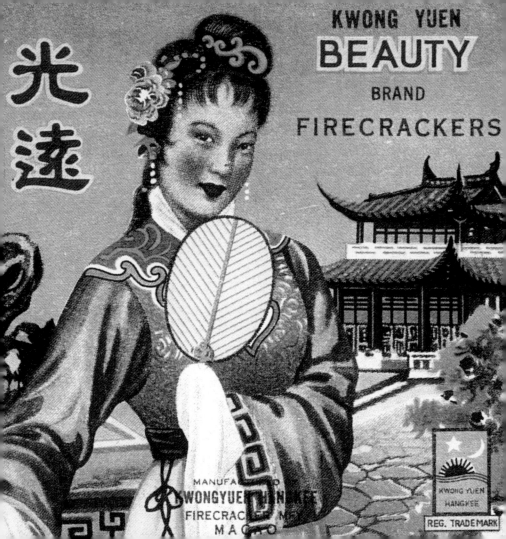

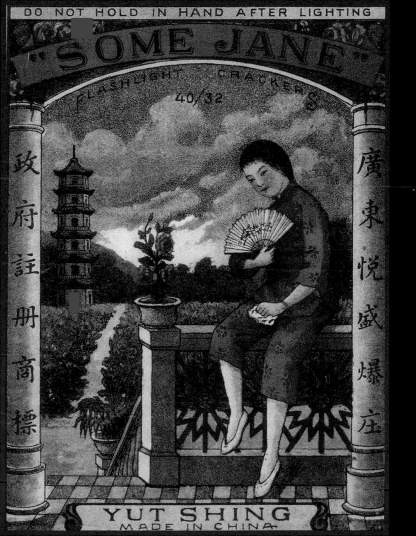

DO NOT HOLD IN HAND AFTER LIGHTING

"SOME JANE"

FLASHLIGHT CRACKERS

40/32

政府註冊商標

廣東悅盛爆庄

YUT SHING

MADE IN CHINA

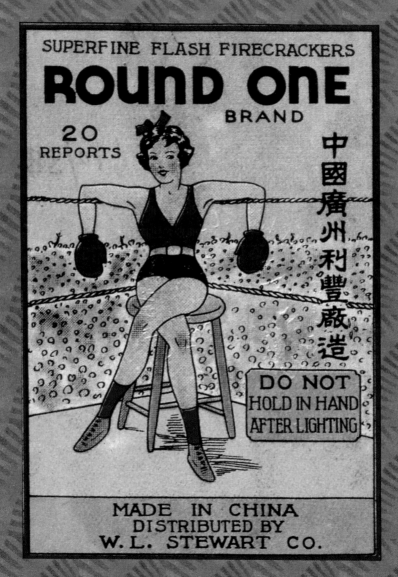

OLD KNIGHT

FLASHLIGHT
40 50

KML

MADE IN CHINA

62

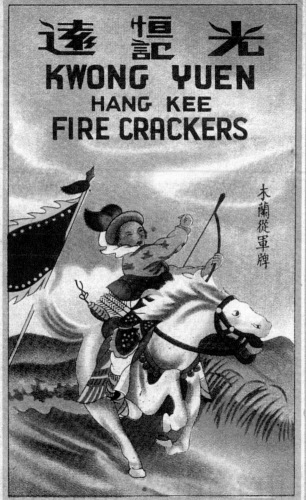

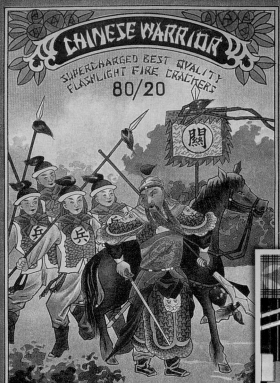

CHINESE WARRIOR

SUPERCHARGED BEST QUALITY
FLASHLIGHT FIRE CRACKERS
80/20

關

KEE CHONG HONG
MADE IN CHINA

DO NOT HOLD IN HAND AFTER LIGH

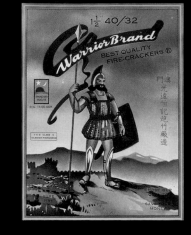

1½ 40/32

Warrior Brand

BEST QUALITY
FIRE-CRACKERS ®

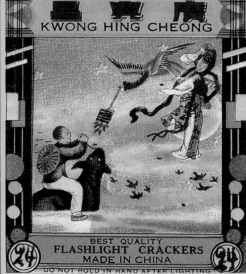

KWONG HING CHEONG

BEST QUALITY
FLASHLIGHT CRACKERS
MADE IN CHINA

DO NOT HOLD IN HAND AFTER LIGHTING

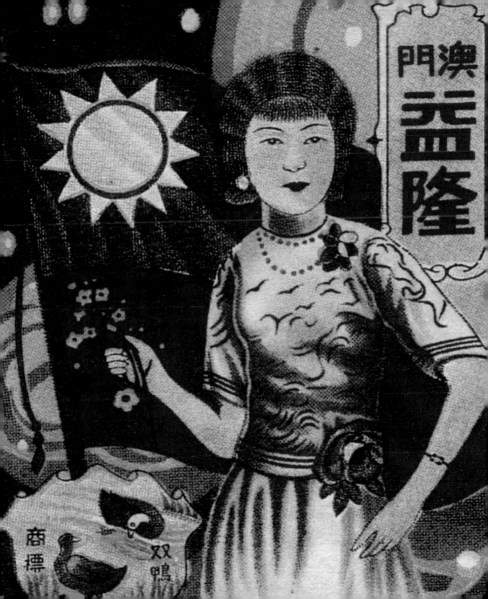

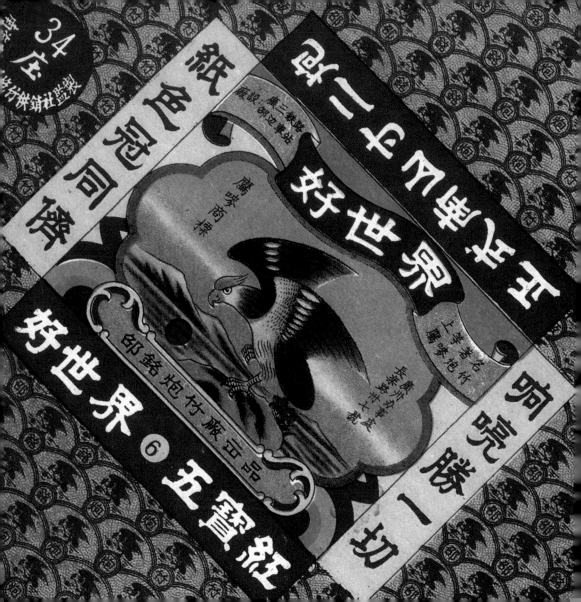

FLYING FEATHERS

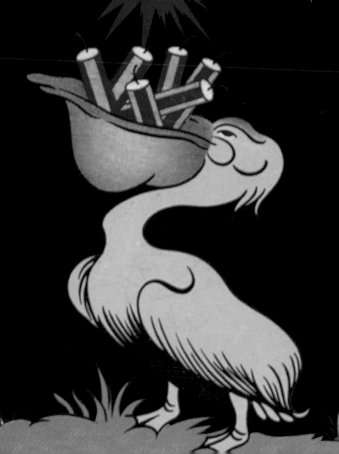

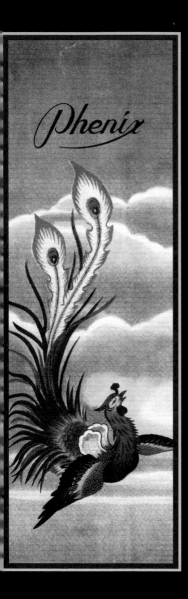

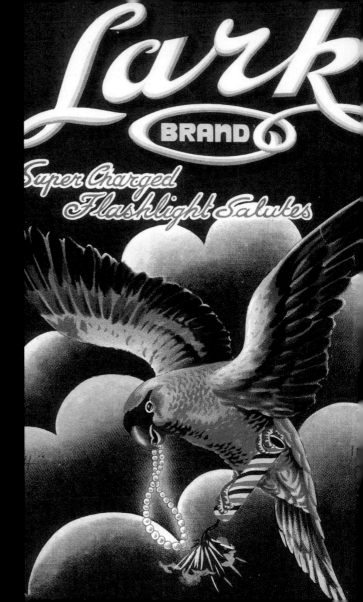

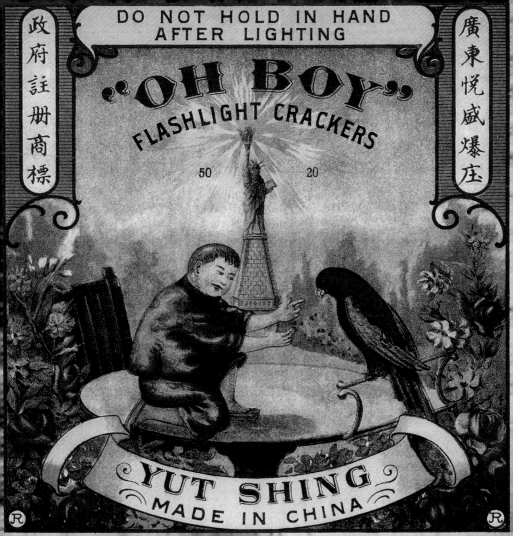

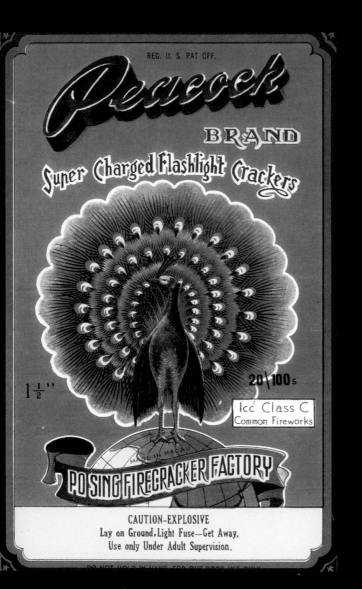

32 REPORTS
EXTRA SELECTED FLASHLIGHT FIRECRACKERS
FLAMINGOES BRAND
"REGISTERED"

炮響光電牌鶴紅

廣州市
道猾廠製造
利豐總經理

MADE IN CHINA
BY
TO YIU
(SOLE PROPRIETORS LI & FUNG, CANTON)
CANTON, CHINA.

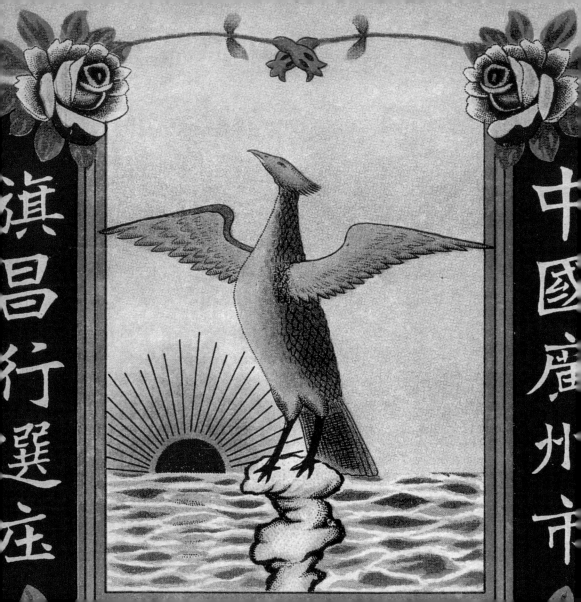

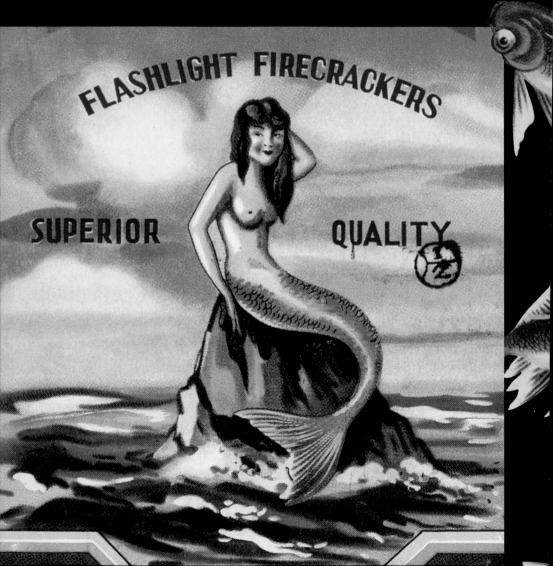

SEA LIFE

75

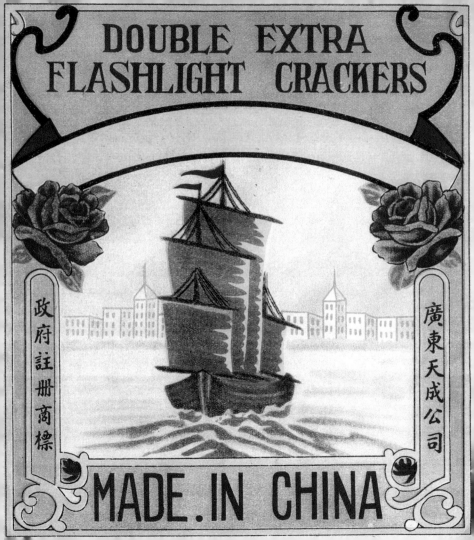

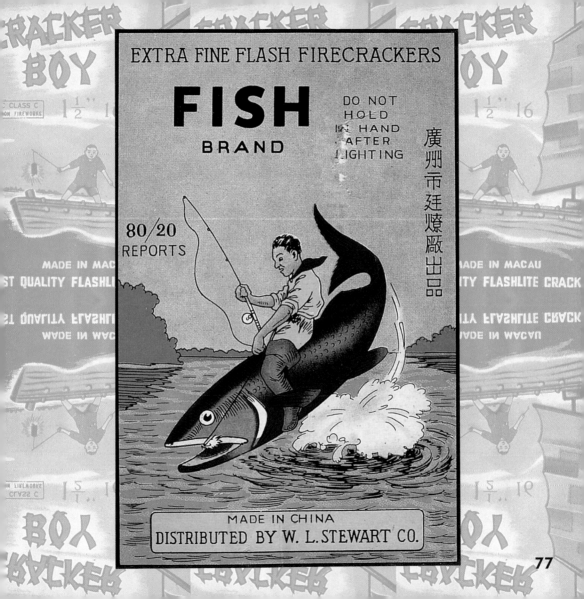

77

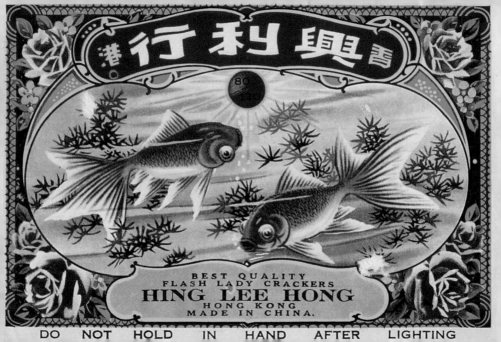

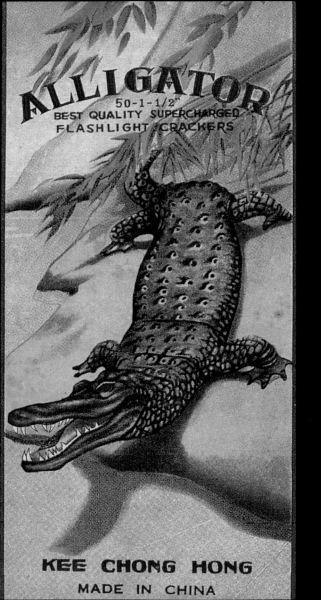

ALLIGATOR
50-1-1/2"
BEST QUALITY SUPERCHARGED
FLASHLIGHT CRACKERS

KEE CHONG HONG
MADE IN CHINA

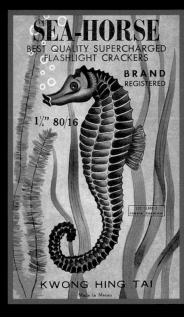

SEA-HORSE
BEST QUALITY SUPERCHARGED
FLASHLIGHT CRACKERS
BRAND
REGISTERED

1½" 80/16

ICC CLASS C
COMMON FIREWORK

KWONG HING TAI
Made in Macau

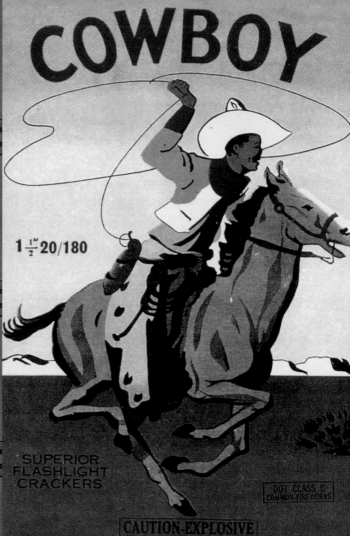

COWBOY

$1\frac{1''}{2}$ 20/180

SUPERIOR
FLASHLIGHT
CRACKERS

DOT CLASS C
COMMON FIREWORKS

CAUTION-EXPLOSIVE
Lay On Ground
Light Fuse — Get Away
Use Only Under Adult Supervision

WILD, WILD WEST

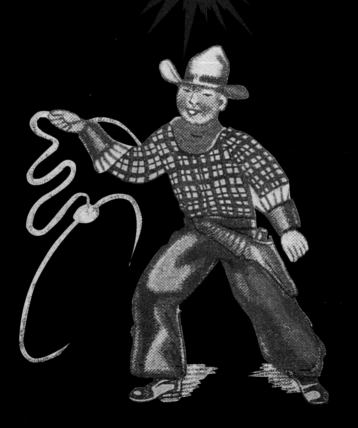

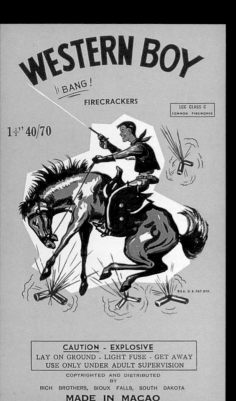

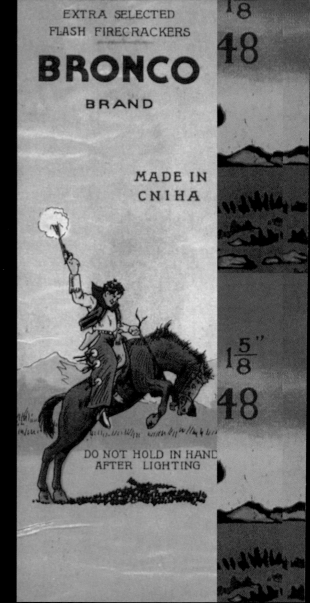

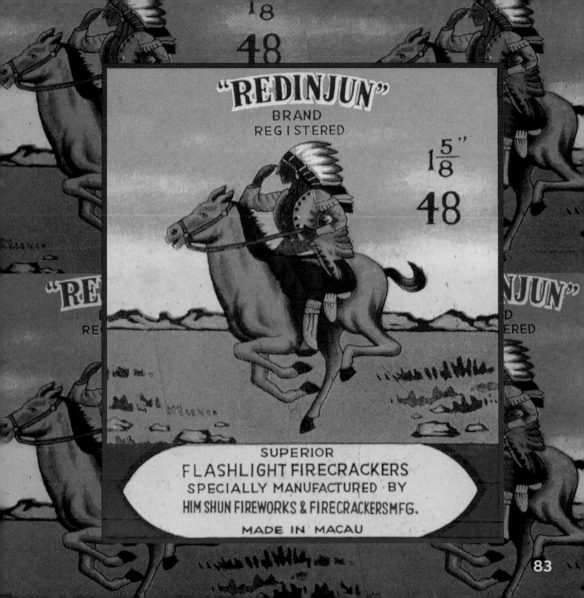

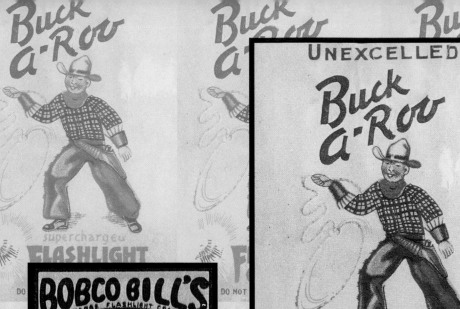

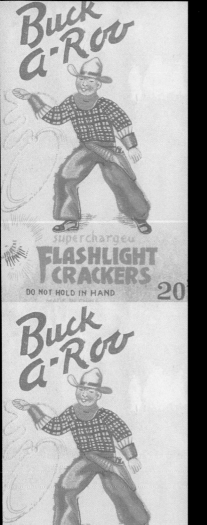

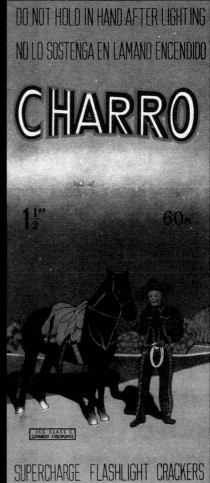

Thunder Crackers

HIGHEST QUALITY

閃電牌

雷鳴炮

ARCHITECTURAL SPLENDOR

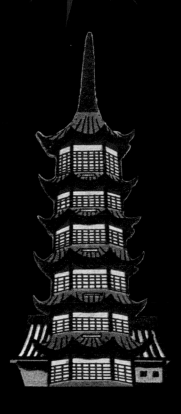

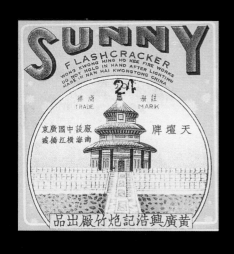

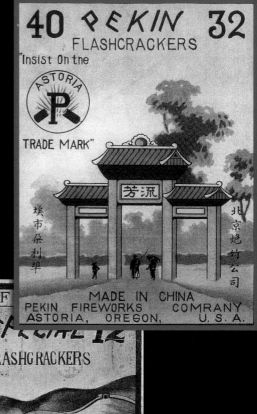

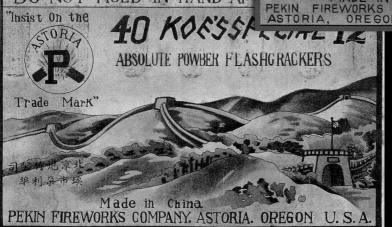

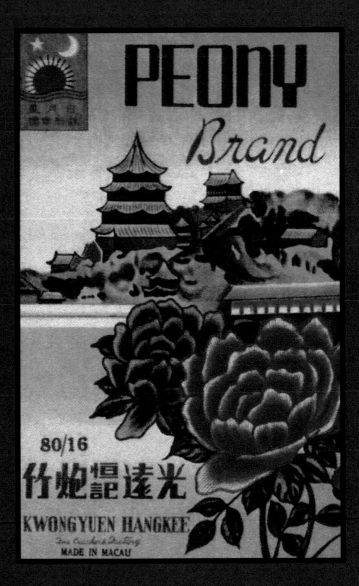

89

King Kong

BRAND

REG. TRADE MARK

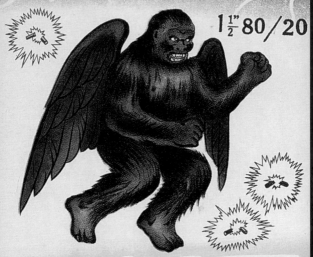

$1\frac{1}{2}$" 80/20

FLASHLIGHT FIRECRACKERS

KWONG HING TAI

MADE IN MACAU

POP CULTURE ICONS

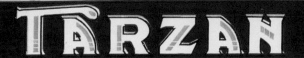

TARZAN

火花光逾電閃
聲浪响過雷鳴

SUPERCHARGED
FLASHLIGHT FIRECRACKERS

MADE IN MACAU

REGISTERED BRAND OF
LI & FUNG LTD. HONGKONG
DO NOT HOLD IN HAND AFTER LIGHTING

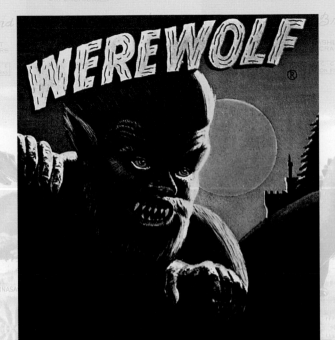

SUPER CHARGED
FLASHLIGHT CRACKERS
HIGHEST QUALITY | ICC CLASS C COMMON FIREWORKS | 1 $\frac{1}{2}$" 40/32

CAUTION - EXPLOSIVE
LAY ON GROUND - LIGHT FUSE - GET AWAY
USE ONLY UNDER ADULT SUPERVISION

MADE IN MACAU
by KWONG YUEN HANG KEE FIRECRACKER FACTORY

SUPERCHARGED

$1\frac{1}{2}$" 70

Brand

FLASHLIGHT
FIRECRACKERS

I. C. C. CLASS C
COMMON FIREWORKS

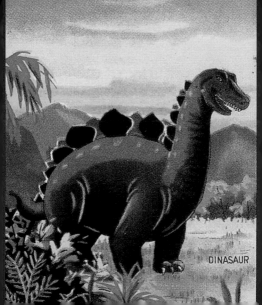

DINASAUR

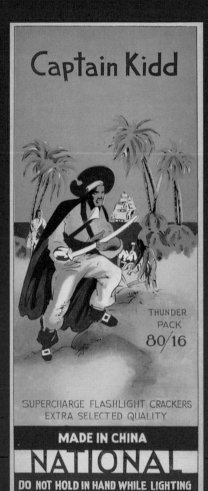

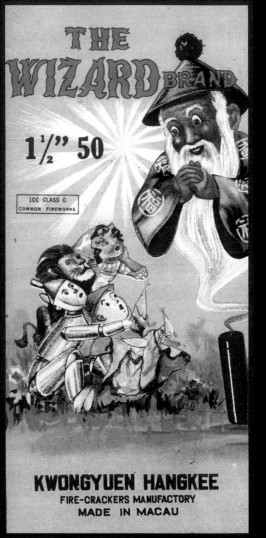

THE **WIZARD** BRAND

1½" 50

1CC CLASS C
COMMON FIREWORKS

KWONGYUEN HANGKEE
FIRE-CRACKERS MANUFACTORY
MADE IN MACAU

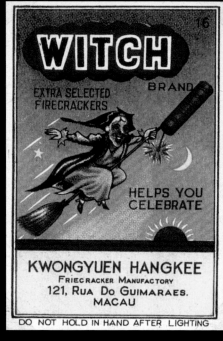

16

WITCH BRAND

EXTRA SELECTED
FIRECRACKERS

HELPS YOU
CELEBRATE

KWONGYUEN HANGKEE
FRIECRACKER MANUFACTORY
121, RUA DO GUIMARAES.
MACAU

DO NOT HOLD IN HAND AFTER LIGHTING

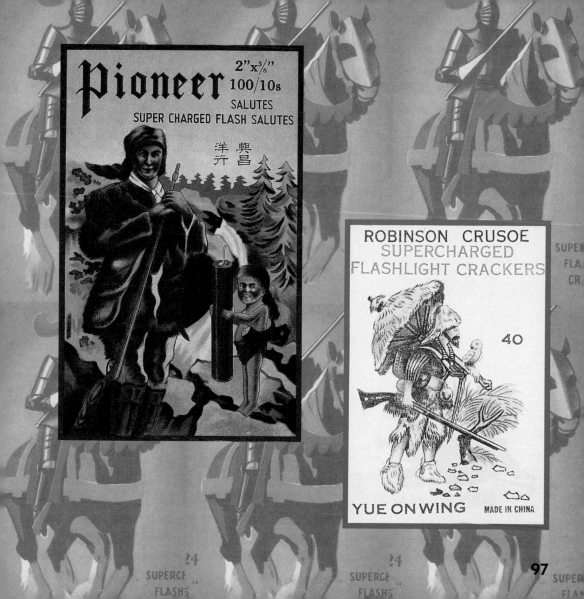

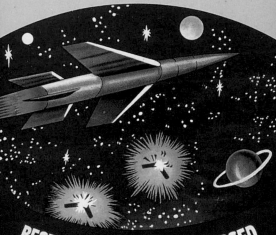

SPACE MISSILE

BRAND

$1\frac{1}{2}''$ 80/16s

EXTRA SELECT
FLASHLIGHT CRACKERS

BEST QUALITY-SUPERCHARGED

BIG BANG

SUPPLIED BY
HING CHEONG YEUNG HONG

EXTRA LOUD

OUTER SPACE

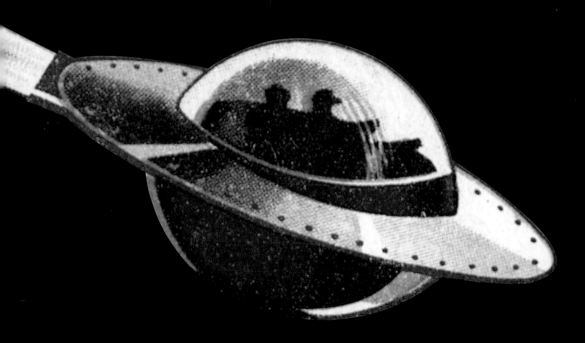

APOLLO

Super Charged Flashlight Crackers

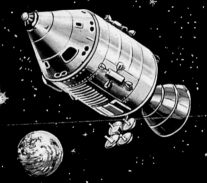

MADE IN MACAU

$1\frac{1}{2}$"

CAUTION-EXPLOSIVE
Lay on Ground, Light Fuse—Get Away, **80** / **16** s
Use only Under Adult Supervision.

PO SING FIRECRACKER FACTORY

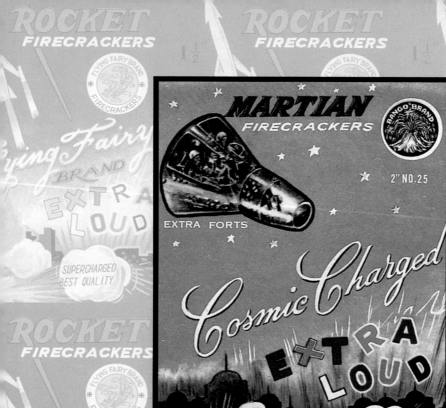

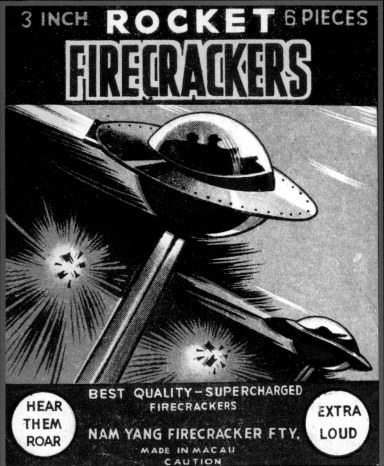

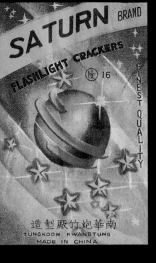

SATURN BRAND

FLASHLIGHT CRACKERS

1½ 16

FINEST QUALITY

造製廠竹炮華南
TUNGKOON KWANGTUNG
MADE IN CHINA

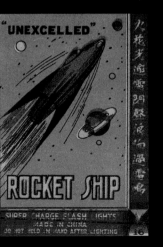

"UNEXCELLED"

ROCKET SHIP

SUPER CHARGE FLASH LIGHTS
MADE IN CHINA
DO NOT HOLD IN HAND AFTER LIGHTING

16

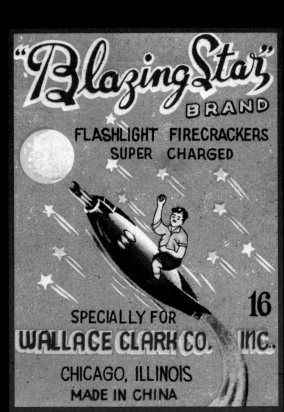

"Blazing Star" BRAND

FLASHLIGHT FIRECRACKERS
SUPER CHARGED

16

SPECIALLY FOR
WALLACE CLARK CO. INC.

CHICAGO, ILLINOIS
MADE IN CHINA

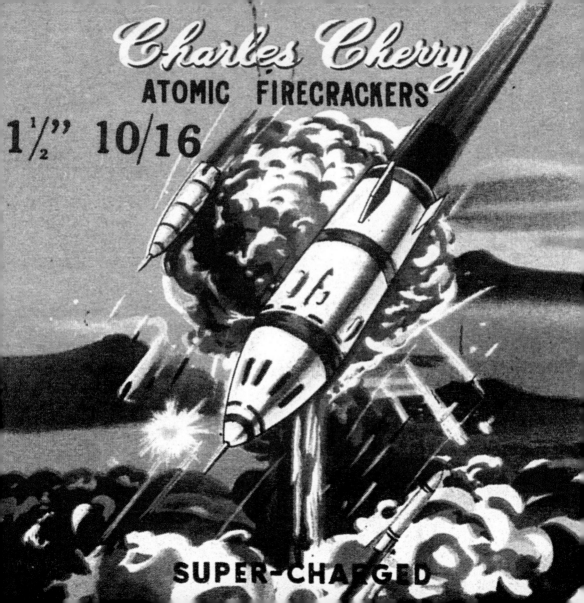

BOMBS AWAY

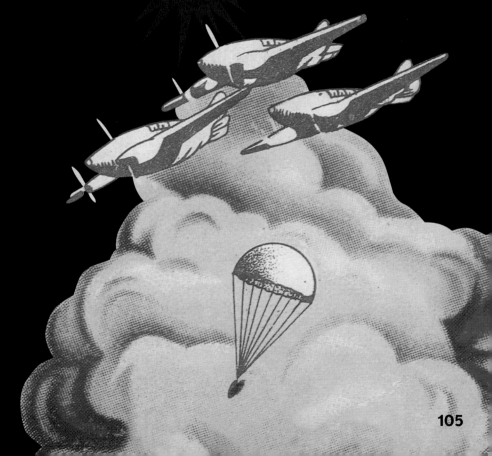

OK

Super Charged Flashlight Crackers

MADE IN MACAU

D.O.T. CLASS C
COMMON FIREWORKS

1 1/2"

CAUTION - EXPLOSIVE
Do Not Hold In Hand
Lay on Ground, Light Fuse—Get Away,
Use only Outdoors Under Adult Supervision.

PO SING FIRECRACKER FACTORY

THIS PACKAGE CONTAINS
1280
1 1/2" CHINESE-TYPE SUPER FIRECRACKERS

BIG BOMB

SUPER
FIRECRACKERS

DOT CLASS C
COMMON
FIREWORKS

CAUTION - EXPLOSIVE
LAY ON GROUND, LIGHT FUSE - GET AWAY
USE ONLY UNDER ADULT SUPERVISION

80/16s

MADE IN MACAU
by KWONGYUEN HANGKEE FIRECRACKER FACTORY

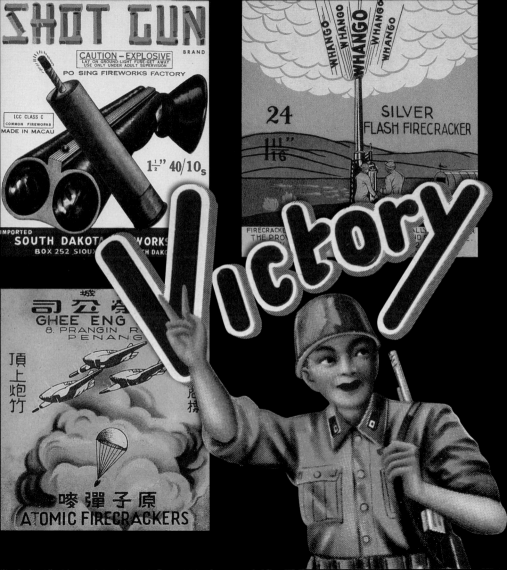

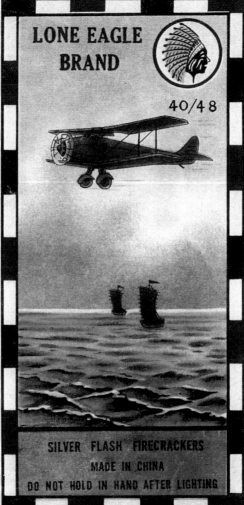

LONE EAGLE
BRAND

40/48

SILVER FLASH FIRECRACKERS
MADE IN CHINA
DO NOT HOLD IN HAND AFTER LIGHTING

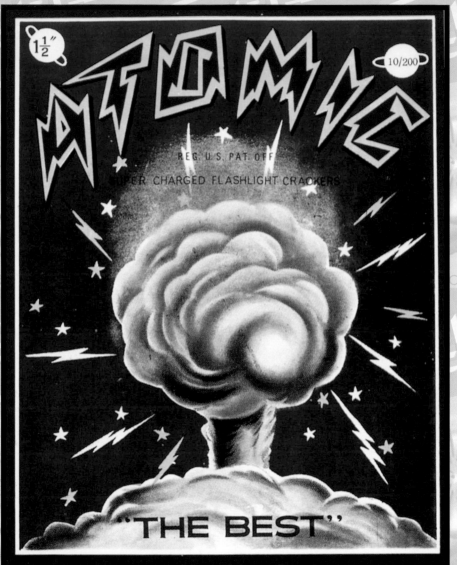

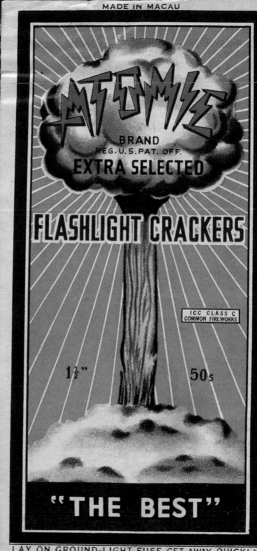

MADE IN MACAU

ATOMIC

BRAND
REG. U.S. PAT. OFF.
EXTRA SELECTED

FLASHLIGHT CRACKERS

ICC CLASS C
COMMON FIREWORKS

1½" 50s

"THE BEST"

LAY ON GROUND-LIGHT FUSE-GET AWAY QUICKLY

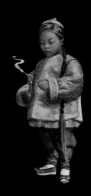

Ten Speed Press
PO Box 7123
Berkeley CA 94707
www.tenspeed.com

Distributed in Australia by Simon and Schuster Australia,
in Canada by Ten Speed Press Canada, in New Zealand by
Southern Publishers Group, in South Africa by Real Books,
and in the United Kingdom and Europe by Publishers
Group UK.

Cover and text design by Katy Brown

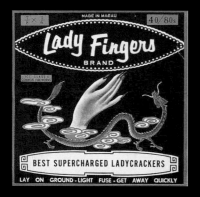

Library of Congress Cataloging-in-Publication Data

Dotz, Warren.
 Firecrackers! : an eye-popping collection of Chinese
firework art / Warren Dotz, Jack Mingo, George Moyer.
 p. cm.
 ISBN 1-58008-903-8 (978-1-58008-903-6)
 1. Labels—China—Pictorial works. 2. Commercial
art—China—Pictorial works. 3. Firecrackers—Pictorial
works. I. Mingo, Jack, 1952– II. Moyer, George, 1948 –
III. Title.
 NC1002.L3D68 2008
 741.6′920951—dc22

 2007050274

Printed in China
First printing, 2008

1 2 3 4 5 6 7 8 9 10 – 12 11 10 09 08

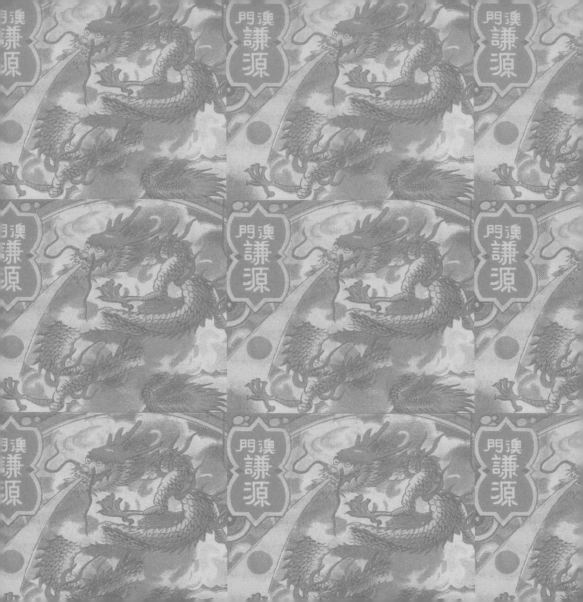